Sharon Hayes
There's so much I want to say to you

Whitney Museum of American Art, New York
Distributed by Yale University Press, New Haven and London

My Personal Appeal to **2,500** Prominent Americans

"FOR TOO LONG I HAVE REMAINED SILENT"

"Your voice and your influence are so much greater than mine, that I urge you to re-examine your stand on VIETNAM

I appeal to you to help lead our country in a new direction toward peace

Dynamic, powerful, influential American Citizens like you, must take the lead in charting a new course for our country, at home and abroad. It's your RESPONSIBILITY, but it is also your OPPORTUNITY to assume the leadership your present position affords. YOURS IS THE VOICE which can determine our DESTINY.

PLEASE DO NOT REMAIN SILENT!

Signed

Bud Berman

BUD BERMAN

LONG PLAY
33⅓ R.P.M.

ALL RECORDING
RIGHTS ARE
THE PROPERTY
OF THE AUTHOR

NOTE: This record has been written, narrated, and paid for by me personally. The views expressed are my own. Public use of all or portions of this record is encouraged, provided prior written authorization has been granted by BUD BERMAN, 2217 Yosemite Drive, Palm Springs, California (92262). Phone area code (714) 327-6586.

© COPYRIGHT 1967 - BUD BERMAN

For Too Long I Have Remained Silent, vinyl record by Bud Berman (self-published), 1967. Text by Saramina Berman.

"You're just like everybody else. You keep talking about how you hate the war in Vietnam, but you never do anything." Thus challenged by his two teenage sons in 1967, my husband was stunned to his core: this time, his kids were right!

As a pioneering American businessman manufacturing inexpensive men's dress shirts in Hong Kong, Japan, and the Philippines since 1960, my husband knew much about the Far East, and was fascinated by its people and their cultures. As a U.S. Army veteran who landed on Omaha Beach during World War II, he knew much about war, which he abhorred.

He could neither understand nor tolerate America's participation in an undeclared war in Vietnam where, by 1967, with 500,000 U.S. troops committed, we were waging conventional warfare against an indigenous, totally committed guerrilla enemy. My husband kept repeating over dinner to our guests, and elsewhere to several others (no one was allowed not to listen), "We are winning all the battles and losing the war." Talking to friends and family was his only defense. Until the challenge from his sons.

That did it. He sat down, wrote out his thoughts, and practiced reciting what he wrote. Then he rented time at a Hollywood recording studio and pressed 2,500 copies of his speech, "For Too Long I Have Remained Silent." Over Christmas vacation, the whole family, including our daughter who was home from college, wrapped and mailed the albums to the 2,500 most influential American politicians, public officials, and businessmen we could think of.

Nothing much happened for forty-five years, although we received many notes of, "Received your record. Thanks a lot." Now, in 2012, my late husband's record is finally reaping the exposure he sought. May his anti-war message make a difference today.

WE WILL TALK
TO RONALD REAGAN

and the

REGENTS

COME: open meeting friday

CAN WE ALLOW REAGAN AND THE REGENTS TO
RAISE OUR FEES AGAIN?
FIRE FACULTY FOR POLITICAL REASONS?
ALLOW ROTC TO CONTINUE AT UC?

don't go to class - COME!

IF YOU HAVE EVER THOUGHT ABOUT MOVING NOW IS THE TIME!

COALITION

← Flyer distributed on campus of University of
California, Los Angeles, 1969.

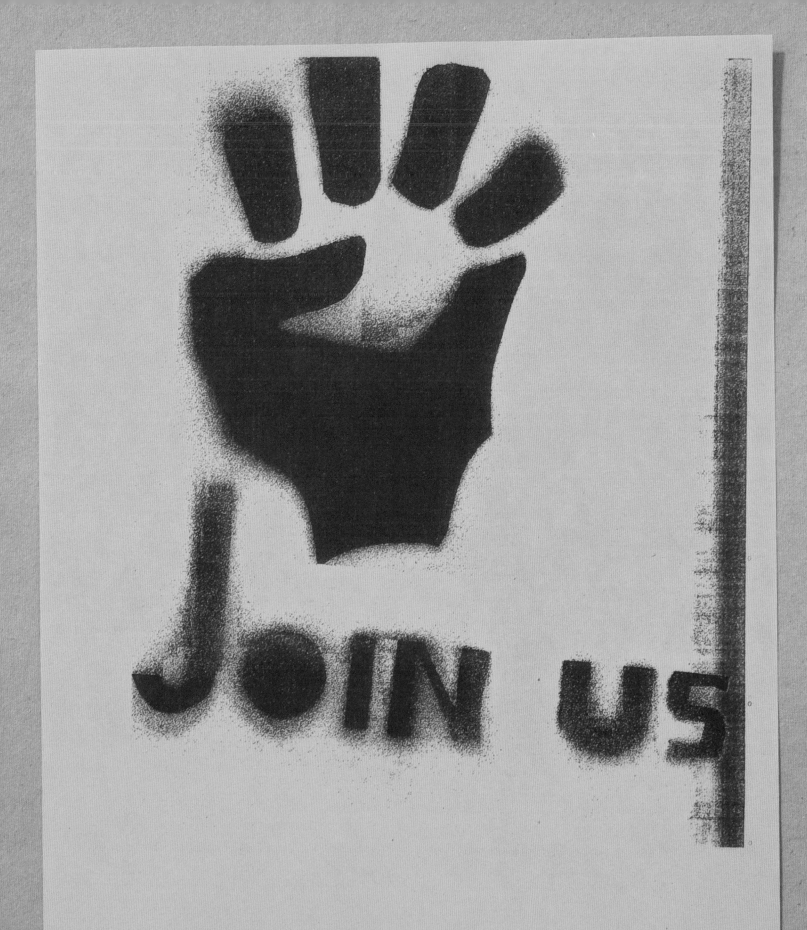

Sharon found this flyer in a folder called "student activism" with other flyers from student strikes in the early 1970s largely in response to the Kent State massacre. Today, this fist invokes the decolonize/occupy actions. Today, we are still responding to spectacular violence. The names Trayvon Martin, Shaima Alawadi, and Rekia Boyd are in our mouths this week. We scramble to find responses that comprehend and dismantle the system of racialized violence that is U.S. law and culture rather than pretending that we can heal these conditions by prosecuting individuals or passing legislation. The banal, background, routine violence of empire—in Iraq, in Afghanistan, in Palestine, in U.S. prisons, in welfare offices, in housing court—also call us to join, to pay for new prisons, to fear terrorists, to report suspicious individuals, to align our grief with state interests. Join us.

We join movements to save our own lives. We want to get to the root causes—to stop this from ever happening again. And to meet our immediate needs—will there be food at the meeting? Will people be nice to me? Is that hot person going to be there? Will someone there be able to help stop my eviction/deportation/benefits termination/parole revocation? Mass mobilization grows out of relationships that form in urgency. We find something we need—to stop the immediate crisis or get company in it—and we expand. Some of the other people there make us uncomfortable but we're working together so we learn to navigate difference, grow in solidarity. Things that seemed unrelated are related—I join you in resisting something I used to think had nothing to do with me. I listen to you because we are in this space that I am invested in to save my life, even though if we had met on the bus I might have been afraid of you.

The U.N. is having its first
A.I.D.S. Confrence

> Demonstration

at

U.N. bet. 43rd & 45th ST

Tues. Oct 20 [1982]

3 - 7P.M

Picket - Join us anytime

ACT - UP

←— Flyer distributed in New York, 1987.

Ancient: You going to the march?

Alien: Yeah.

Ancient: I don't know, I'm feeling a little old for that kind of thing.

Alien: You look great. We need you to represent.

Ancient: Seems like that's been my responsibility forever. And who is this we.

Alien: Word.

Ancient: I'm just tired.

Alien: I hear that.

Ancient: All these folks coming with their energy, we gotta change everything. Things gonna change no matter what. Hey. What you got there?

Alien: It's something we have in the future. It cleans atoms, and it's a communication device, and a vibrator, and a vaporizor, and it's my I.D.

Ancient: Military technology, I'm sure.

Alien: Probably.

Ancient: I used to be a video artist, in the '90s. But I got sick of using the leftovers of boardrooms and corporate dickheads and all that as my medium.

Alien: Look, I get it, but you're being kinda negative. The whole point is to transform what we've got into something better.

Ancient: Most of my collaborators are dead.

Alien: Come with me to the march.

Ancient: Alright. For you, cutie.

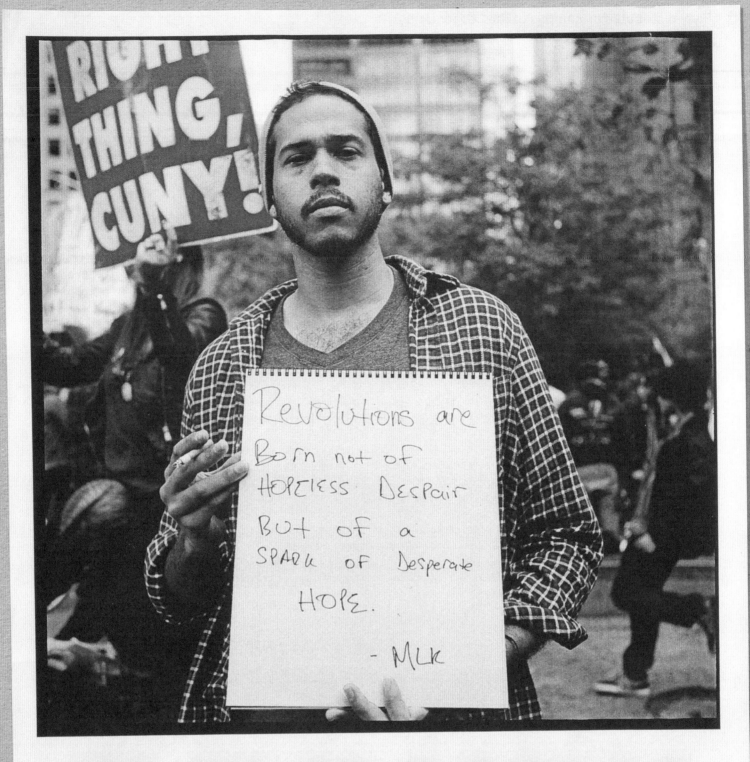

Flyer distributed on campus of The Cooper Union, New York, 2011. Text by Christhian Diaz.

Hay distancia entre mi mamá y yo. Viene a vivir conmigo por que desde hace un año no ha logrado conseguir trabajo. Como no la he visto en un par de años, añoro la oportunidad de compartir espacio con ella otra vez. Me gustaría que se siente en las reuniones de organización a las que yo voy. La educación es un tema central de las conversaciones, y me acuerdo que cuando nos mudamos para Estados Unidos de Colombia hace 13 años, ella siempre me recordaba que adquirir una educación era la clave para el éxito. Nuestro éxito: el mío, y el de ella.

Mi mamá ha emigrado varias veces con la esperanza de encontrar una mejor vida. Mientras que encontrar un lugar apropiado y oportunidades es importante, la educación es esencial para sobrepasar las limitaciones que ella tuvo en su formación. Así como mi mamá ve la educación como una forma de liberación de la pobreza, ella quería que yo fuera a la escuela, y su apoyo por mis estudios fue incondicional.

Para mi mamá, esa liberación tiene que ver con la habilidad de tener más, pero mi educación me liberó de ese deseo. Yo estudié arte, y poco a poco, mientras aprendí a apreciar lo material por medio del hacer, quede con deseos que no podrían estar más lejos del "éxito" convencional. La aspiración a tener más cosas se me escapa. Ahora lucho por menos! Rechazo la noción de que cada uno de nosotros debemos poseer una de cada cosa. En las reuniones, hemos estado pensando en economías alternativas y formas para apoyarnos el uno al otro, para saber que podemos comprar un solo azadón y compartirlo con la comunidad.

Tal vez mi mamá y yo queremos las mismas cosas, y aún así nos encontramos lejos del otro, en diferentes lados del cuarto. Pero los dos estamos anhelando liberación.

There is a distance between my mother and me. She's moving in because over the past year she hasn't been able to find work. Since I haven't seen her in a few years, I welcome the chance to share a space with her again. I would like her to sit in on the organizing meetings I attend. Education is central to the conversations, and I remember that when we moved to the United States 13 years ago from Colombia, she always reminded me that getting an education was the key to success. Our success: mine, and hers too.

My mother has emigrated many times in hopes of finding a better life. While finding the right place and opportunities is important, education is vital to overcoming the limitations she experienced growing up. Because my mother sees education as a form of liberation from poverty, she wanted me to go to school, and her support for my studies was unconditional.

For my mother, that liberation is about the ability to have more, but my education liberated me from that desire. I studied art, and, slowly, as I learned to appreciate materials through making, I was left with desires that couldn't be further from conventional "success." The aspiration to have more things escapes me. Now I fight for less! I reject the notion that each of us should own one of everything. In the meetings, we have been thinking about alternative economies and ways to support each other, to know that we can buy only one plow and share it with our community.

Perhaps my mother and I want the same things, yet we find ourselves far away from one other, on different sides of the room. But we are both yearning for liberation.

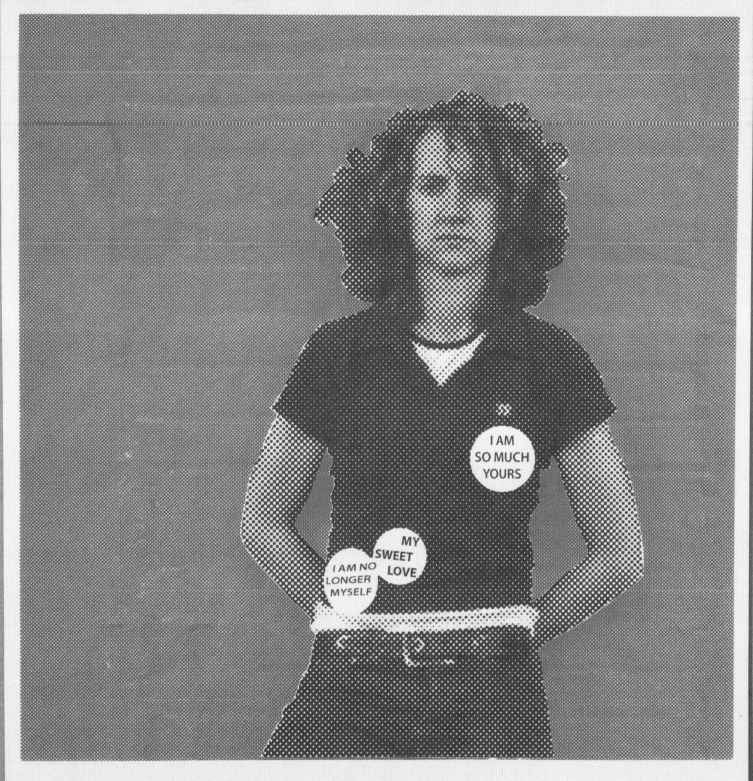

I KNOW THAT THE EARS ARE THE ONLY ORIFICE THAT CAN'T BE CLOSED.

← Sharon Hayes, *I Know That The Ears Are The Only Orifice That Can't Be Closed*, silkscreen, 2008. Text by Lauren Berlant.

I. Attention!

It's not true: the ears aren't the only orifice that can't be closed: the skin, the nose . . . People say this phrase all the time none-theless—like Jacques Lacan, in the *Four Fun Concepts of Psychoanalysis*. What he means, though, is not really that the ears can't be stopped. He means that you can't stop the noise, the noise of relationality, fantasy and desire. Noise is in you, around you, is you.

So Sharon Hayes cannot quite know what her artwork asserts. But she knows *something* about optimism: the optimism of attention to love.

Attention at root means to stretch toward something. Hayes wants you to crane your neck toward the way her attention to you has made her not herself. She is making a political point about proximity. Attention! You're now susceptible. You're now responsible.

II. Inattendance

The eyes, in contrast, can be closed. They can shut out a girl or a world. But Hayes is looking at you frankly, forcing herself into your eyes, from over there. Still, being seen isn't enough. She wants aesthetic intimacy: do you feel me, feel the revolution of relation?

Since your eyes are hearing-impaired, here are some stickers, bodily thoughts pulsing to the beat of your incomplete encounter with her. Projecting across distance shapes Hayes's oeuvre, her claim for love as a political concept.

III. In attendance

What's the story? "I am no longer myself, my sweet love, I am so much yours." The stickers are a defense, a seduction, and a demand for care. Intimacy's many performative genres induce collective potential for belonging. But the social drive is an aggressive one too. She presses you to show up for a relation that you are already in: this is the commons.

This broadside, disembodied and yet with erotic presence, is from a woman whose assertion of a general claim forces you to reoccupy the social in love's name.

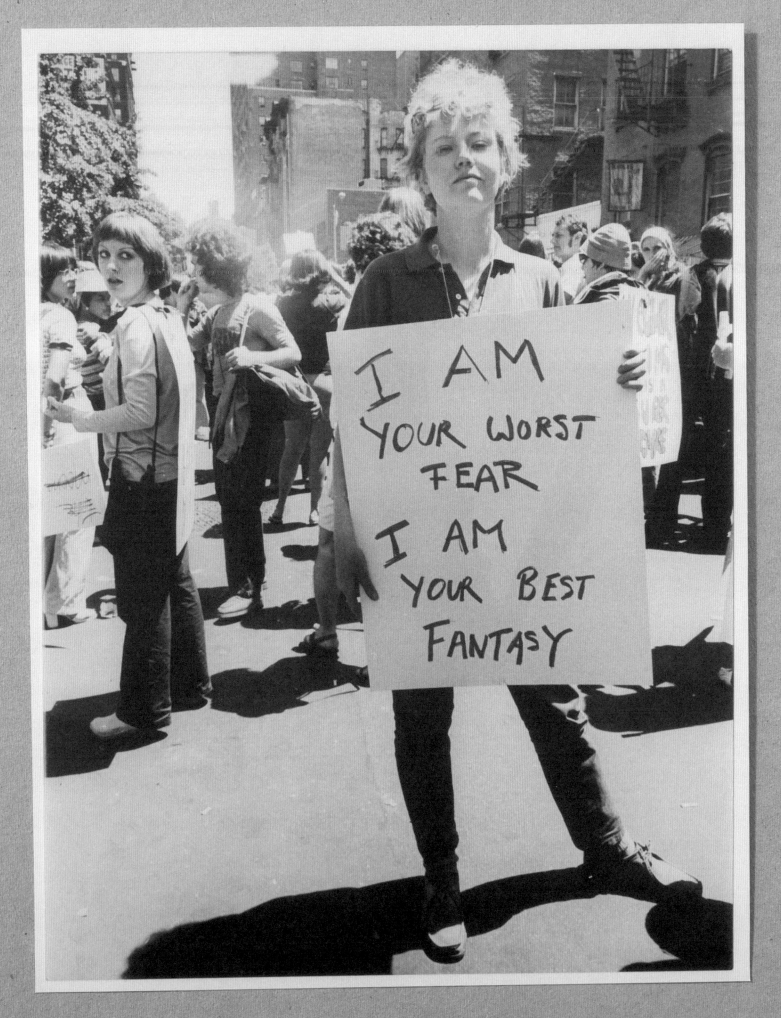

Revolutionary Love drew its inspiration from the slogan and subsequent poster, "I am your worst fear, I am your best fantasy," which I created for the first Gay Pride March in 1970. The photograph by Diana Davies is silent, but it captured a moment in time when voices demanded justice and social change; voices that spoke for a generation and shaped the conscience of their time through radical political action and violent street demonstrations. Silence did indeed equal death long before it became the Act-Up chant.

The slogan "I am your worst fear, I am your best fantasy" evolved from the rage and frustration felt by lesbian activists. Male politicians and police who in the light of day railed against us as "man-hating, ball-busting bitches" salivated at the thought of hot lesbian action in pornographic films and girl-on-girl action with prostitutes, girlfriends, and in some cases, wives. "Free love" was not free for lesbians. It came with a huge price tag that few in 1970 were willing to pay.

Lesbians were social and political outcasts. The "Radical Left" was not dealing with sexism or homophobia; black activists did not see "gay rights" as a legitimate civil rights or political cause; the "Women's Movement" labeled us "The Lavender Menace" and, worse yet, "Lavender Herrings."[1]

The look on Donna Gottschalk's face still elicits feelings of proud defiance and determination that kept us going in the face of an avalanche of repression, rejection, violence, and just plain fear that was descending on us in 1970 and still is today in the guise of assimilation. The "outlaws" have been silenced but our voices, our words, our history live on.

1 Susan Brownmiller, "Sisterhood is Powerful," *New York Times Magazine*, March 15, 1970.

REVOL...ONARY
LOVE...

...UBLIC PERFORMANCE !

...M

...R BEST FANTASY

FLAMBOYANT QUEERS OR THOSE
WHO CAN PLAY THE PART !

We are looking for a minimum of 75 people to speak a text about love, politics, gay power and gay liberation on the occassion of the 2008 Republican National Convention. We are looking for lesbians, gay men, bisexuals, transmen, transwomen, queers, fags, dykes, muff divers, bull daggers, queens, drama queens, flaming queens, trannies, fairies, gym boys, boxing girls, pitchers, catchers, butches, bois, FtoMs, MtoFs, old maids, Miss Kittens, Dear Johns, inverts, perverts, girlfriends, drag kings, prom queens, happy people, alien sexualities or anything else you want to be or are and wish to bring out for the event! FOR INFO www.creativetime.org/rnc

← Sharon Hayes, *Revolutionary Love: I am Your Worst Fear, I am Your Best Fantasy*, publicity flyer for performance, 2008.

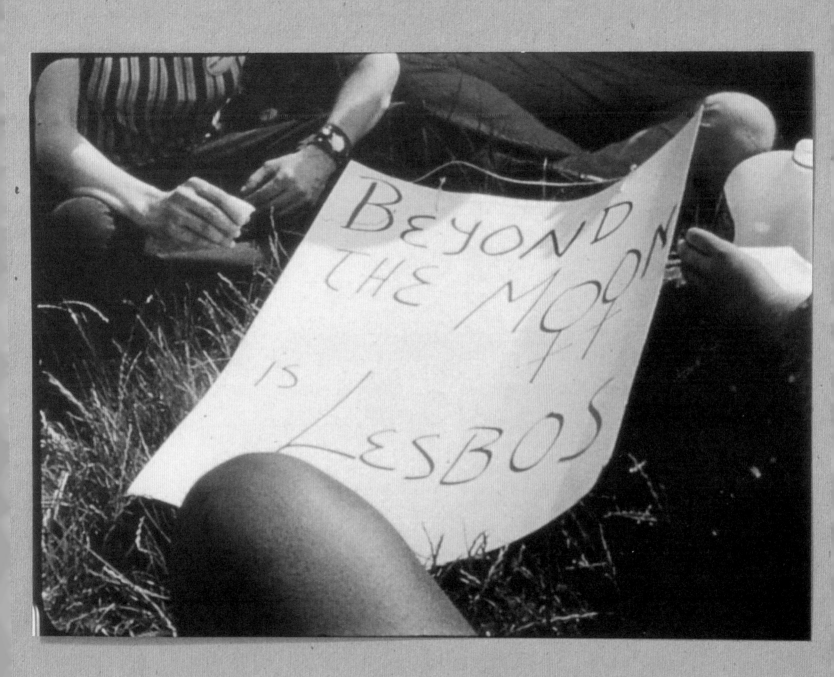

In this image the public address is retired. The sign sits on the ground as people chat and rest. While they are kissing or joking or talking politics or narrating the events of the day, the sign lies inert. It isn't being carried or propped up for passersby to read. Nor has it been tossed aside. It is surrounded: by two hands on one side, a foot on the other, a leg underneath. I imagine it as a title. It could be the title for that moment with those women, or for that day.

It is not actually true that beyond the moon is Lesbos. That is a fiction. The sign is not stating a demand or claiming a right or condemning a wrong; the sign is stating a fiction.

But what is the value of a fiction here, among radical acts of protest, where vulnerable people publicly and flamboyantly defend their sexual desire and confront a humiliating oppression? Amid their defiance is this sweet fiction reminiscent of a line from a children's book. The power and potency of fiction is that it allows us to imagine other realities. It gives us permission to locate our own reality. So the sign may be saying, "Your reality is not mine." Onlookers, passersby, hecklers, and even friendly supporters have returned home, gone shopping, or visited a museum while these women have traveled beyond the moon to Lesbos.

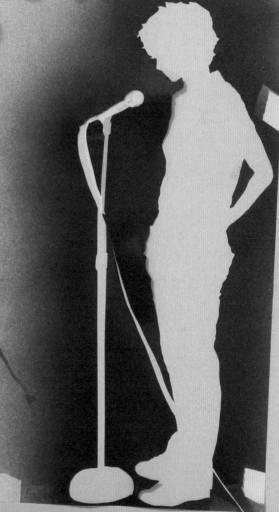

Everything Else Has Failed ! Don't You Think It's Time for LOVE?

Describing the lover's dilemma, Jacques Lacan observed: "When, in love, I solicit a look, what is profoundly unsatisfying [is that] you never look at me from the place from which I see you. Conversely, what I look at is never what I wish to see."[1] Hence the untraversable divide between the lover and the beloved, one that historians analogously encounter with the object of their devotion– the past. Because the subject can never fully coalesce with the other, Lacan famously stated, "There is no sexual relation." This can be extended, allegorically, to the historian, when we say: *There is no historical relation*.

Hayes's performance *Everything Else Has Failed! Don't You Think It's Time for Love?* embodies this paradox. The title derives from an image of a man holding a sign emblazoned with those words at a protest in 1967. That was the year of the Summer of Love, the Newark race riots, the Israeli Six-Day War, the SCOTUS case Loving v. Virginia, and the Vietnam War. Amid this turmoil a man calls for love, and is answered some forty years later by Hayes. Across the historical divide that separates them, Hayes reads anonymous love letters—microphone in hand—on the streets of New York, enacting the lover's wistful pining for their beloved.

What is this object, exactly? In part, it's the historical event addressed by the lover's language: *Don't you remember, my sweet, when we were shouting about revolution?* This address, pivoting off the singular-plural pronoun "you," psychically collapses the private into the public. But can she (we) ever truly coalesce with the inferred absent beloved/event? No. But it is the desire to do so that's poignant. To simply imagine this union in the field of politics, aesthetics, and love brings power to the powerless so that we can—as Alain Badiou has urged all such time travelers—*keep on going*.

1 Jacques Lacan, *Seminar XX, Encore*, excerpted in *Feminine Sexuality: Jacques Lacan and the école freudienne*, Juliet Mitchell and Jacqueline Rose eds. (New York: W. W. Norton and Co. 1982), p. 143.

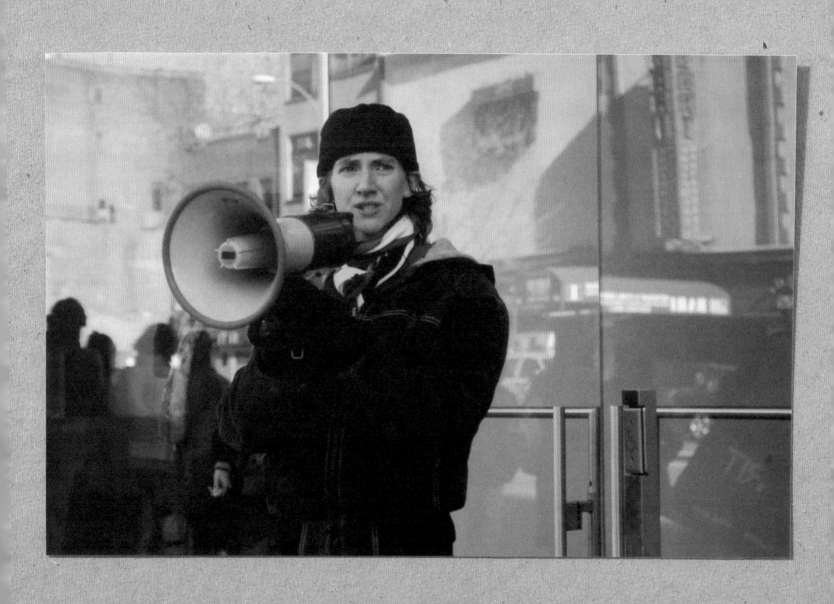

← Sharon Hayes, *I March in the Parade of Liberty But as Long as I Love You I am Not Free*, performance still, 2008.

26

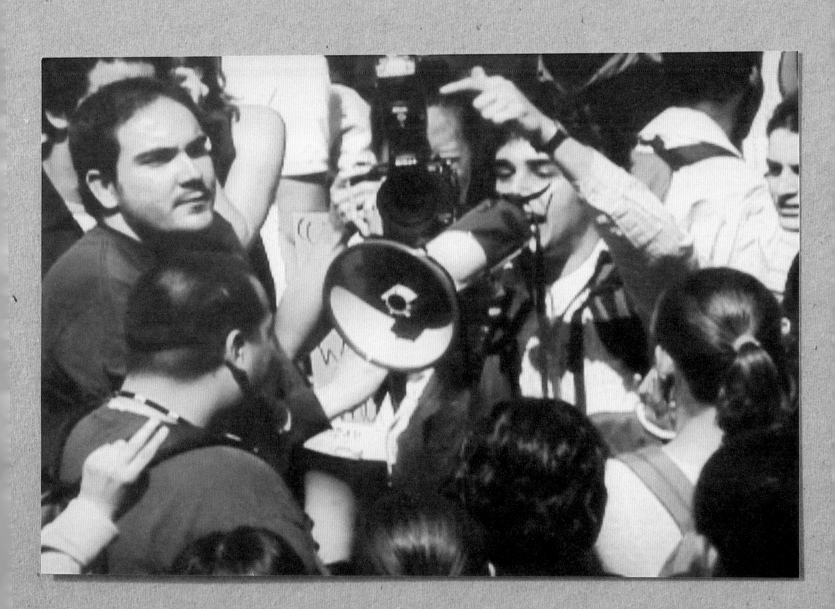

Collective listening requires amplification. These video stills index the ubiquity of the loudspeaker as the technical infrastructure for the speech of political protest, only recently rivaled by the human microphone. Held close to the speaker's mouth, the bullhorn juts outward, and in the midst of a crowd, its flared opening suggests a face that is all mouth. One imagines the intensity of the amplified sound, as a person in its trajectory blocks her ears with her hands. In another shot, the loudspeaker is clenched in a raised fist above the crowd, transmitting words uttered into a detached microphone and pointing to the location of the sound's source. Distinct from its use for commercial speech, the loudspeaker's presence at a protest emphasizes the necessity for retransmission. The human microphone emphasizes the importance of listening and recapitulating as key to the collective politics of protest, further breaking down the already tentative distinction between speaker and listener.

In these images, the listeners' sightlines are dispersed, their focus refracted. One imagines standing in the back of the crowd, where attention is turned farther from the speaker's amplified voice, further toward one another. A cacophony of desires. Collective listening is tactical and fragmentation is one of the ways we retain individual differences. The satisfaction of the human microphone is the immediate expression of these differences via our retransmissions. Parts of information are lost; the process slows down to an excruciating speed; identification is questioned at every breath; the vulnerability of collectivity is amplified. It is a new form of speech collectively produced.

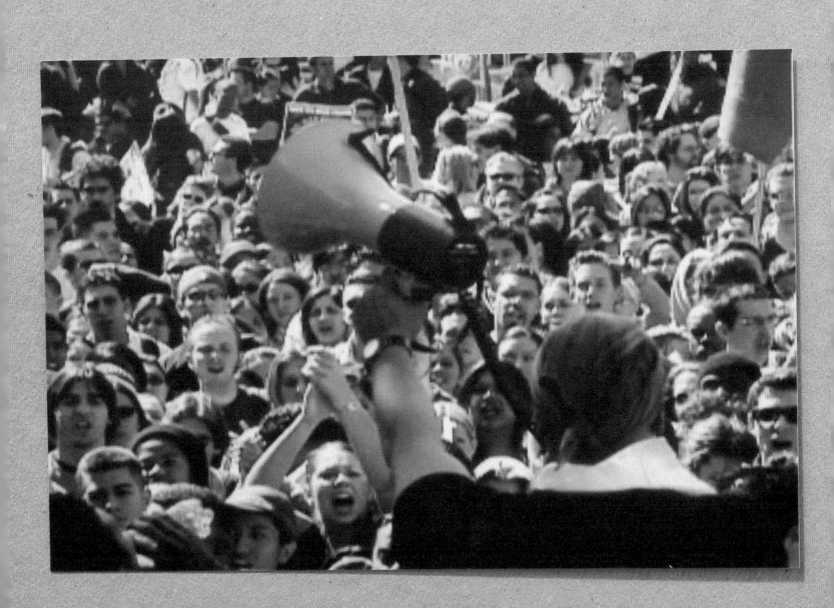

← Sharon Hayes, *We Knew We Would Go to Jail*, video
 still, 2003.

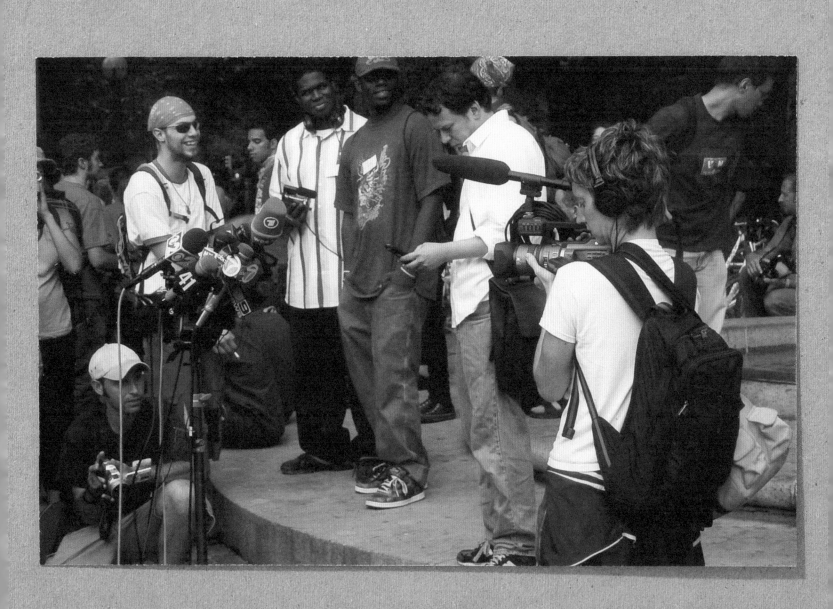

Check one: The microphone is an apt metaphor for power: it both amplifies and constrains. The microphone projects you outward, but only if you offer it your voice, and only along the airwaves it directs. Your breath becomes a dull burst and echoes out to listeners who have made this speaking possible: a sounding of power. Not only a metaphor, the microphone-effect is very real. It enables and forecloses inclusion and, more importantly, upholds the false promises of inclusion, inviting us in—into the official chambers of legitimated public address, in from outside. Available scripts of shame, confession, triumph, and confrontation are repeated with a difference that struggles to hold its differentness (gender, sexual, racial). A tenuous hold on a difference that also is tamed, as testimony, apology, speech.

Check two: In the generative spaces of the Occupy/Decolonize movements, the mic check is a call to arms: you shout "mic check," I repeat, we gather to listen. It brings temporary form to the noise of the crowd. Those gathered talk together through the "human mic": you speak, we repeat and pass your words to those beyond us, who repeat and pass on to others, who repeat. A technical way of sidestepping laws banning amplification, the human mic becomes something else (a feedback loop)—a way to bind speaker and audience, audience and audience, demanding engagement and activity. Outside these temporary zones, the mic check and human mic mutate and multiply as creative, aggressive ways to interrupt official address and its exclusive inclusions: politicians, bankers, talking heads called out at their conventions and galas. Mic check! As I am dragged away, you take it up, repeat and pass on, the human mic a form of solidarity, address as redress, an emergent difference with no guarantees, but possibility nonetheless.

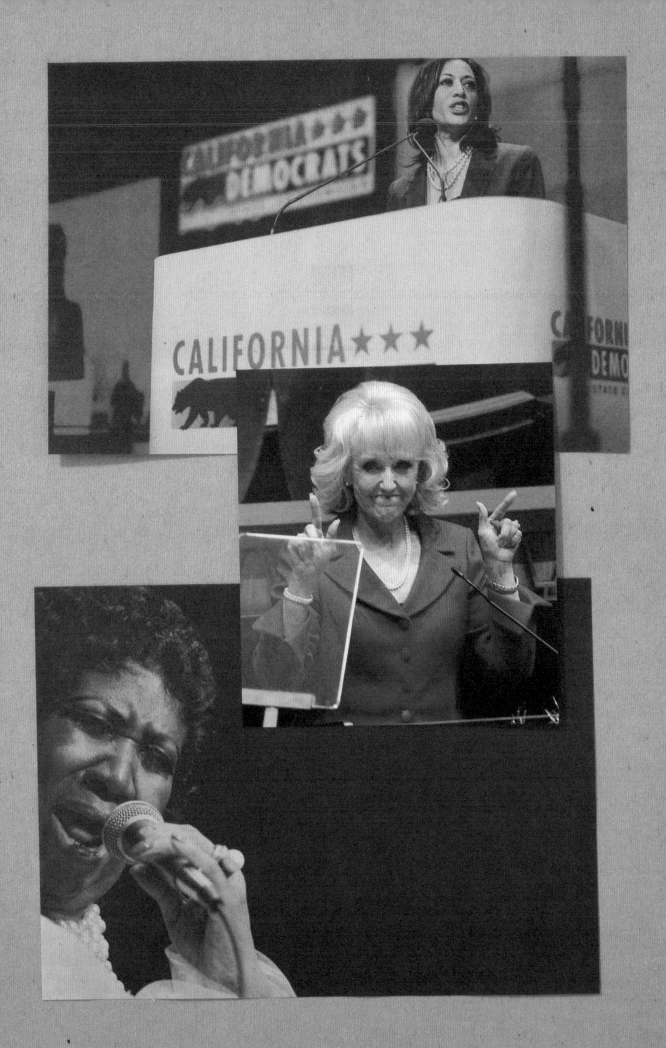

At a conference called "Schizoculture," held at Columbia University in 1975, the speakers were magnetic and illustrious: William Burroughs, R.D. Laing, John Cage. The audience—graduate students, artists, writers, and freelance intellectuals. Later on, "Schizoculture," organized by Sylvere Lotringer, would be billed as the conference that launched French theory in America.

The gathering took place in a lecture hall or auditorium that seated about 300 people, a raucous, animated group, who heard, for instance, a lecture about psychoanalyst Jacques Lacan, and were told that "the unconscious is structured like a language." R.D. Laing said that graduate students were the most depressed population in any society.

All day, men—no women—took the microphone and spoke. There was always a buzz in the audience, whispers, an audible hum of excitement. Then it was time for John Cage. He walked onto the stage and began to speak, without the microphone. He stood at the center of the small stage and addressed the crowd. He talked, without amplification, and soon people in the audience shouted, "We can't hear you. Use the mic. We can't hear you." John Cage said, "You can, if you listen." Everyone settled down, there was no more buzz, hum, or rustling, there was silence, and John Cage spoke again, without the microphone, and everyone listened and heard perfectly.

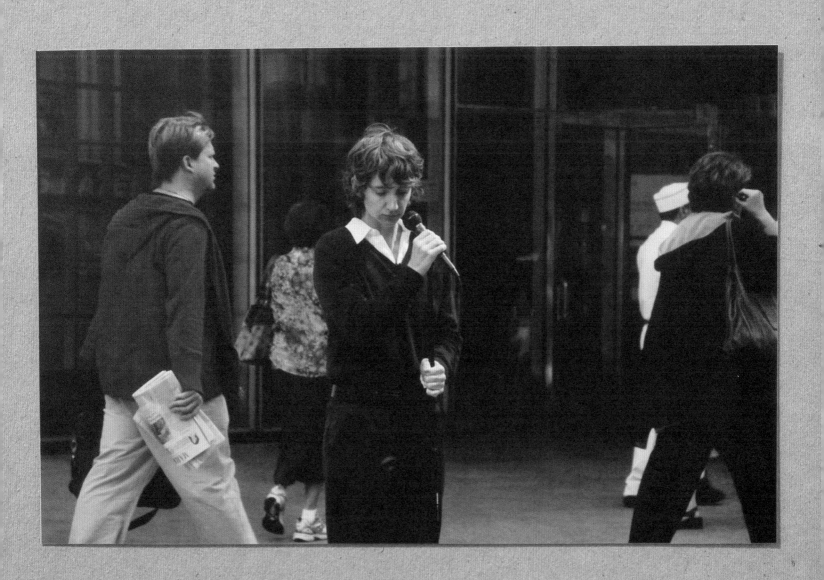

Sounds subside. *A woman and a microphone.* Her movements paused. *She stands in the midst of lunch-time traffic.* Possibilities open. *I stop.* More than one beginning comes to mind. *I try to find her gaze.* She considers each one of them. *I blink.* A silent procession of actions. *To distinguish her from others.* She takes a breath. *People passing.* A breath to herself, not yet for another. *When I look again, I have lost her out of sight.*

She looks down. *There are moments that separate themselves from the present.* Rehearsed in silent anticipation. *They move through time with those who listen.* Her thoughts focus. *Forwards and back.* Words pull together. *Language is risk.* But also a source of protection.

I find her again, still in the crowd. Unexpected. *I feel a vague sense of desire.* Tension begs her to release. *No one acts unless to manifest a latent self.* Her head still bowed. *A moment of nothing.* She is waiting to find a crack in time and space. *Expecting everything.* Not yet. *In a stranger.*

Her hand's grab tightens. *An absence that suddenly turns present.* She imagines words. *To account for the bodies who speak them.* To find a voice. *For that which has not yet come.* To lose a voice. *Recognizable to others.* Between silence and utterance. *I listen.*

She looks up. *To my eye.* Disclosing her image. *To my ear.* With utter conviction. *Revealing herself.* Rivers of language. *Landscapes of action.* Stream through unfolding ideas. *Words are deeds.* Cutting shapes into space. *Still unexpected.* A leap of imagination. *Licks my ear and becomes mine.* Distinct and equal. *A window opens.* Thought and speech. *Become ours.* Connecting us. *No guarantees given.* Now.

I need to speak to you. I am beside myself. You
want me to buck up. To make my own way in the world
and leave you to do the same. You seem to see love
as some form of control. You told me we were in a
quandary about the present. You told me we were in
search of a future. And then when I stepped in to
chart a path, you told me to mind my own business.
Why can't I want for you the same things I want for
myself? I was trying to take care of you, trying to
protect you from the storm. The world seems to be
falling apart and though we haven't been apart for
long there are misunderstandings that linger be-
tween us. If history repeats itself these misunder-
standings will only grow deeper. In case you
haven't noticed, I look graceful on the outside but
inwardly I am at war.

← Sharon Hayes, *Unannounced*, five flyers distributed
at Frieze Projects, London, 2009.

Surely you know that desire is cruel?
Love is so easily wounded.
~~I feel certain I'm going mad again.~~
Nothing is real but you.
~~There may be a very war in a few days.~~
I feel as though a part of me has been torn
away, like a limb in battle
Nothing like this has ever happened to me.
There may be war in a few days and
There are millions of things I want to
say that can't be said.

I am so much yours, I am not mine.

So I choose my words to you carefully
and say goodbye.

Sharon Hayes, *Everything Else Has Failed! Don't You Think It's Time for Love?*, page from script, Friday, September 21, 2007. Text by Cristóbal Lehyt.

Writing down the words that will be performed.

They are forming themselves into public sentences that will be spoken in midtown Manhattan.

The words are about love and they will connect to a shared context, ways to engage with a reality that is overwhelming.

Loss as an empowering moment of clarity, of deep connection to one's feelings and to what surrounds us.

We look at the notes of the text that will be heard on the street, the corrections and organizing of a constructed effect.

It has an objective, a call to move towards what is most important and urgent in the listener.

The writing is easy to read, clear even in its corrections.

We look at it now as a document in process.

We linger in what the work will become, in this moment, doing something to the reader.

Address to the Nation on the Economy

February 5, 1981

Good evening.

I'm speaking to you tonight to give you a report on the state of our Nation's economy. I regret to say that we're in the worst economic mess since the Great Depression.

A few days ago I was presented with a report I'd asked for, a comprehensive audit, if you will, of our economic condition. You won't like it. I didn't like it. But we have to face the truth and then go to work to turn things around. And make no mistake about it, we can turn them around.

I'm not going to subject you to the jumble of charts, figures, and economic jargon of that audit, but rather will try to explain where we are, how we got there, and how we can get back. First, however, let me just give a few ``attention getters" from the audit.

The Federal budget is out of control, and we face runaway deficits of almost $80 billion for this budget year that ends September 30th. That deficit is larger than the entire Federal budget in 1957, and so is the almost $80 billion we will pay in interest this year on the national debt.

Twenty years ago, in 1960, our Federal Government payroll was less than $13 billion. Today it is 75 billion. During these 20 years our population has only increased by 23.3 percent. The Federal budget has gone up 528 percent.

Now, we've just had 2 years of back-to-back double-digit inflation -- 13.3 percent in 1979, 12.4 percent last year. The last time this happened was in World War I.

← Sharon Hayes, *My Fellow Americans: 1981–88*, script, 2004–06.

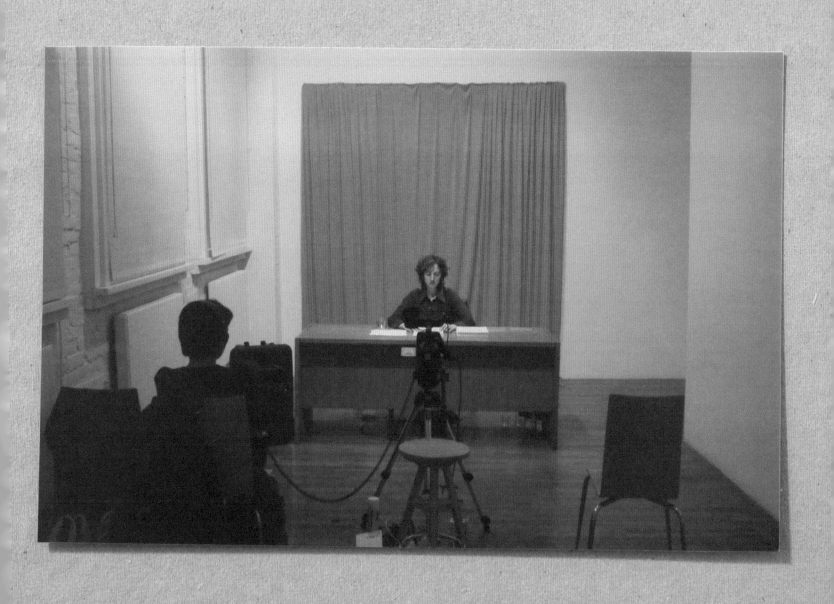

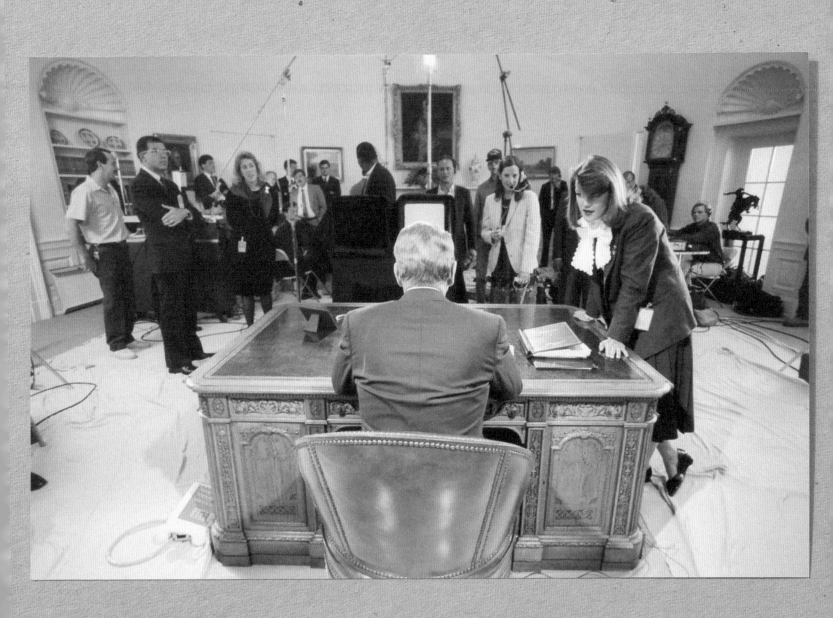

← Ronald Reagan and presidential aide Elizabeth
Board, address to the nation from the Oval Office,
Washington, D.C., October 14, 1987.

What ever happened to Ben Webster?

I don't know but I had this dream. A series of graveyard visits, witnessed from across a wide roadway. Formal outings, but only partially viewed—the end of the processions. All the graveyards were gated, walled, or fenced in, an armored architecture hiding a lot of marble, granite, and grass within.

In each event some vehicle—a large car or hearse—carrying the deceased Ben Webster would have to break through an unmanned barricade on its way to the graveyard, through thick waist-high concrete obstacles embedded in the road. Approximately ten to twenty feet of road would be broken up, shattered by the vehicle by the time the graveyard site was reached. Next the vehicle would sit idling, and then suddenly crash through the wall, or fence, or gate. There were occasionally open entrances to all the different graveyards—six once, and later three. But never did the vehicle enter through an open entrance. It was clear that when entrances did appear they were only decoration. The scene kept changing, with angle shifts, close-ups, pans, a different vehicle, always large, imposing, sedan-sized, sparkling, sometimes black, sometimes another color (once fire-engine red), different men driving, always formally dressed and wearing hats, then another graveyard, different barricades. One or two of the scenes had dreary weather, and one was especially sunny.

A dream-film, with its *mise-en-scene* of the barriers that surround absence. How the complete blanking of something has to be contained, is incomprehensible otherwise. Also another counter-memorial, because it couldn't have happened, and therefore couldn't be remembered. Ultimate freedom is nothing without a wall or fence, I suppose.

I was later told that Ben Webster left America for good in 1964, and is actually buried in Assistens Cemetery in the Nørrebro, Copenhagen, the same graveyard as Kierkegaard, the spy of god, whose philosophy that man is singular (and can be buried anywhere) was at one time a radical idea.

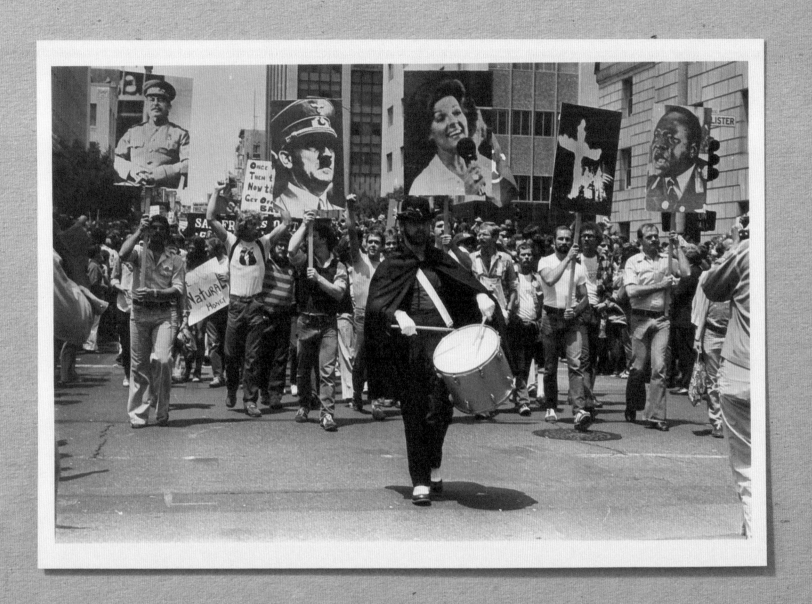

← Gay Day Parade, San Francisco, 1977.

This little two-minute 16mm clip was one of the first items I ever purchased back in 1986 when I began collecting LGBT film materials. Having devoured Vito Russo's pioneering history of homosexuality in the movie *The Celluloid Closet*, I amassed an encyclopedic knowledge of LGBT film titles that had me scouring the pages of the film collector's monthly broadsheet, *The Big Reel*. The publication was packed with ads (primarily typed, often handwritten) from other individual film collectors across the country who were buying, selling, and trading 16mm and 35mm prints from their collections. Each month I would meticulously review columns and columns of film titles looking for the movies Vito wrote about.

At some point early on I expanded my field of interest to include anything that sounded campy or queerly resonant or featured stars I knew to be gay (for instance, I have a great PSA for the Sister Elizabeth Kenny Foundation from 1958 in which Sal Mineo makes a plea for polio research funding). Coming across Anita Bryant's name (the title was listed as: *Anita Bryant: Pie-in-the-Face*), I immediately snapped up this extremely rare 16mm film print.

Raw, immediate, wonderfully gay, and undeniably funny, *Anita Bryant: Pie-in-the-Face* is a segment from a Des Moines, Iowa, 1977 television news broadcast in which one of Bryant's "Save Our Children" press conferences is zapped by a pie-wielding gay activist. It is a historic document of pre–ACT UP creative queer activism — a terrific example of gay people taking a stand against the virulent homophobes of the Christian Right. Contemporary LGBT folks may want to note that last year's glitter bombings are situated within a proud heritage that includes this imaginative culinary political gesture.

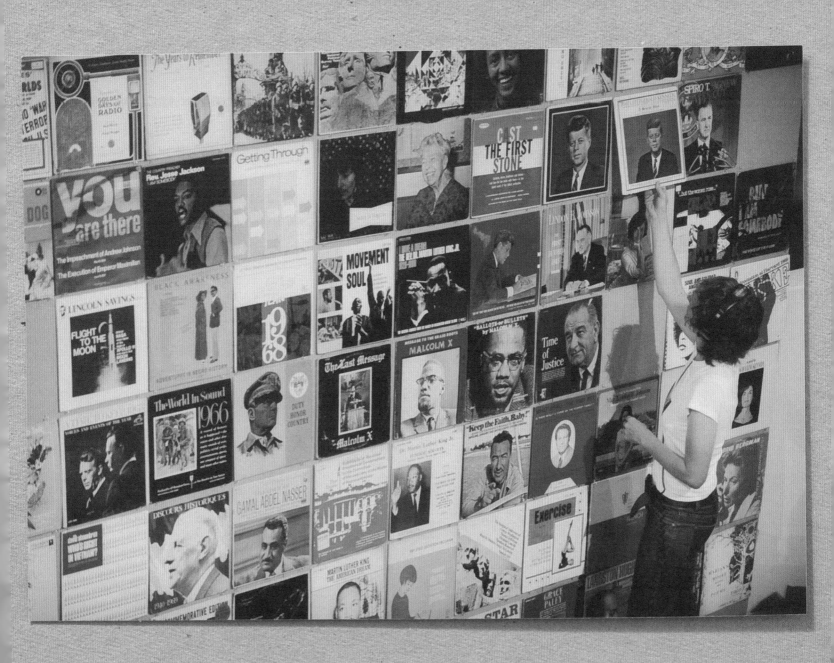

Albums, each its own trip in the way-back machine. A grid-like composition where content is king. A flowchart, a historical-strategy game with console and platform. Challenge, choice, ever-changing goals, and the nasty cheat done Amerikkka-style. Me, the ungrateful Oreo, surrounded by the best, well-intentioned. Carrying Julius Lester's *Look Out, Whitey! Black Power's Gon Get Your Mama* for a history report. Then still carrying it, like a Bop Gun, for protection. It's vaporware until the albums remind you. Analog noise as distinctive as Kodachrome. Bodies shuffle, crowd falls silent, room presence: the sound of the Apollo one night and Malcolm X speaking. Alex Haley interviewing Black soldiers in Vietnam about "coming home"—what they hope will change, what they know never will. What they're fighting for. Roberta Flack's *Love Songs*. An Afro so round and powerful, it is the medium. Drop the needle and it consoles, long play. Radio silence then back to Haze. Cut the excess and flowchart appears. The remaining albums include: *Flight to the Moon*, Nikki Giovanni, Jesse Jackson, *1968*, Malcolm X, *Movement Soul, You are There, The World in Sound 1966*. Diagram the components—goals not yet won, game broken, each album its own superpower and solution. Alone or together, there's a quiet, computational moment when you try to see if it could possibly work. The game that's not the game. The *"What if . . ."* Playtest. *"One-Two-Three-Go!"* Skill, strategy, luck with no clear way to win. But Haley and the Black soldiers are chuckling in that melodious and bitter way that only a we/them can—*"Nigger, you ain't bulletproof!"* The punch line, the snap, delivered through laughter that makes <<sides>> split. Noisy, vinyl perfection, its timing is flawless. Inspired, you try your system again and again, until someone, *anyone* wins: *"One, Two, Three, Go: Rock–Panthers–Scissors-Giovanni-Pigs!"*

THE WORLD IN SOUND 1974

Narrated by EDWARD DE FONTAINE AND TOM MARTIN
Produced by ASSOCIATED PRESS

Supervising Editor JIM WESSEL
Recording Engineer ROBERT HOLLAND

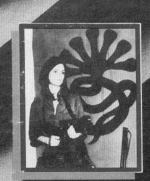

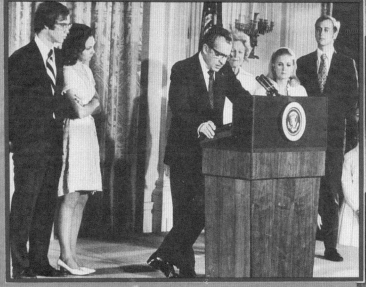

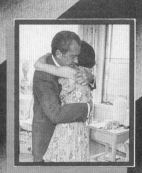

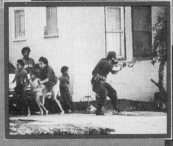

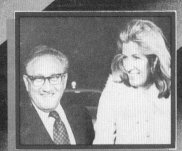

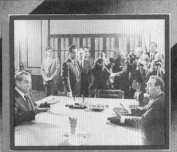

NBC Radio and AP Radio

The World in Sound, vinyl record, 1974.
Text by Kabir Carter.

Dear Sharon,

As I try to write, I am fixed by a fact—I have my own memories of 1974.

Recently, I secured my mother's seventies-era photographs from my uncle. The circumstances leading to my possession of her photographic negatives, slides, prints, and proof sheets need not be recounted here. But as I contemplate this one year, and my mother's photographs, I find myself standing among the pieces of a Volkswagen Beetle resting on a tiled floor.

Notated in my mother's slightly curved, handwritten block letters, the first line of one proof sheet reads: BARNSDAL - RON COOPER EXHIBIT. Half of the sheet—fourteen images in all—records me interacting with the car's fragments, walking around the dismembered remains of its chassis and body. I fixedly attend to the parts, periodically lifting an item to gaze upon it more closely, perhaps to better understand its texture and contours. Behind all of this, a wall-mounted grid of enlarged photographs shows others disassembling the car.

Beside these photographs is another memory. I watched a video that chronicled a journey the Volkswagen made—possibly its final ride. A camera follows the Volkswagen along a freeway. Eventually, the car is driven down a flight of steps, and arrives at the site of its installation. I don't know if this is accurate. Maybe the car wasn't driven indoors. Maybe the journey was imagined.

Before, I thought Dewain Valentine made the installation. My mother said he once opined that I had the hands of an artist. This might be false and is somewhat embarrassing. My recollection is complicated by these fragments and incomplete accounts. I've begun to put things together, but have so far only assembled a partial form.

PATRICIA HEARST: Mom and Dad, I'm okay. I'm (pause)
I had a few scrapes and stuff, but I'm (pause) they've
washed them up and they're getting okay. And I've caught
a cold, but they're giving me pills for it and so uh
I'm not being starved or beaten (sigh) or unnecessarily
frightened. Um, I've heard some press reports and so
I know that STEVE and all the neighbors are okay, that
no one was really hurt, and I also know that the SLA
members here are very upset about press distortions
of what has been happening.

They have nothing to do with the August 7th
Movement. They have not been shooting down helicopters
or shooting down innocent people on the street. I'm
kept blindfolded usually so that I can't identify anyone,
and my hands are often tied but not generally they're not.
And uh, I'm not gagged or anything, and I'm comfortable,
and I think you can tell that I'm not really terrified
or anything, and I'm okay.

I was very upset though to hear about the
police rushing in on that house in Oakland, and I was just
really glad that I wasn't there, and I would appreciate
it if uh everyone would just calm down and not try to find
me and not be making identifications because uh, they're
not only endangering me but they're endangering themselves.

67

Document from FBI files of Patty Hearst kidnapping case, 1974. Text (*Communiqué to Sharon*, 1979–2012) by Dennis Adams.

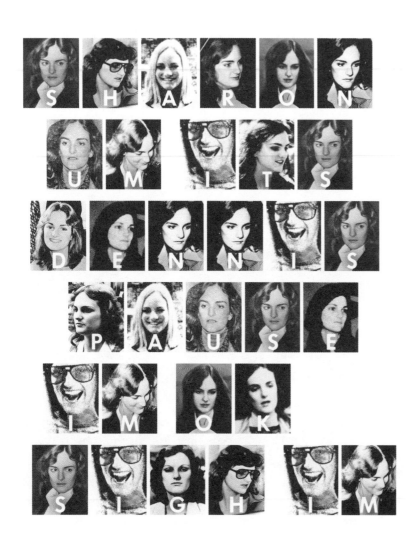

FOURTH FEMALE VOICE:

This is Information Intelligence Unit Four.

On March 9th, 1974, this unit was directed to deliver a taped communique to the news media. Due to intelligence reports received by the Federation in regards to FBI attempts to intercept and suppress any communications between the SLA and the people, a double decoy system was set up. One tape, with a gasoline credit card, was sent to Radio Station KDIA and another tape, enclosed with an automobile credit card, was sent to KSAN. We of Unit Four notified KDIA first as to the location of this tape which allowed one of two things to happen. Either KDIA, without telling the public or the Hearst family, turned it over to FBI who in turn suppressed it keeping it from the Hearst family and public, or the FBI intercepted it before KDIA got it and suppressed it from getting to the Hearst family and the public. In any event, this allowed the second tape to get through to KSAN because the FBI thought that the tape they had already intercepted was the only one sent out. We of Unit Four are sending our copy of the tape because it is more audible. Please pass it along.

In March 1974, when the Symbionese Liberation Army was sending audiotaped "communiques" to alternative radio stations regarding their recent kidnapping of the heiress Patty Hearst, radio had become the primary means by which the counterculture in America communicated with its constituency. It was the only branch of the media capable of subverting authority through the interjection of the voice of a young generation seeking an alternative to what they perceived to be the inadequacies of government. (Five months after the first SLA audiotape appeared, Nixon resigned.) The SLA's delivery of audiotapes to radio stations could be understood as a kind of event, and they chose KDIA, the largest soul and funk radio station in the San Francisco area, with a primarily African-American audience, as a primary site for that event, thus purposefully locating it, and their mission, firmly within the context of both race and class.

On the March 11th evening news, KDIA broadcast the audiotape, in which a young woman explains why the SLA sent a second, decoy audiotape to another radio station, KSAN, an underground rock radio station described by Frank Zappa as "the hippest radio station in the universe." Announcer Scoop Nisker signed off with: "That's the news; if you don't like it, go make your own." The SLA took him at his word. Alternative radio took its lead from the underground press, which in 1968 numbered over 500 and reached millions. The SLA felt confident that KSAN would broadcast their audiotape, though KSAN felt reluctant to be a mouthpiece for the SLA's demands, or the violence it advocated. This paradoxical situation reflects the deep confusion that surrounded radical political movements in America during the 1970s, and the complex unresolved questions that their actions opened up. Sharon Hayes' re-speaking of the SLA's event as a new, "not-event" evokes Walter Benjamin's observation that "to articulate the past historically does not mean to recognize it 'the way it really was' [. . .], it means to seize hold of a memory as it flashes up at a moment of danger."[1]

1 Otto Ranke quoted by Walter Benjamin, cited by Nishant Shahani, *Queer Retrosexualities: The Politics of Reparative Return* (Lanham, MD: Lexington Books, 2011), 22.

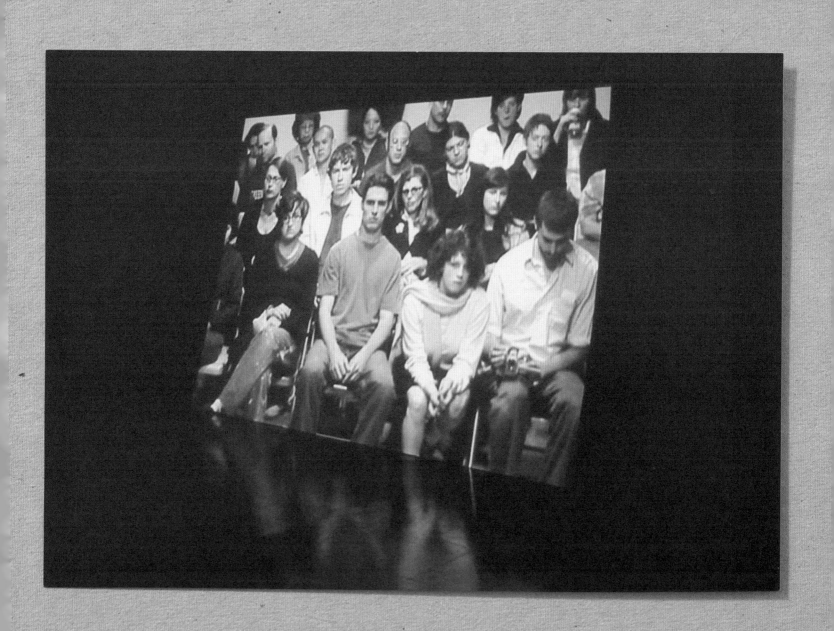

← Sharon Hayes, *10 Minutes of Collective Activity*, video still, 2003.

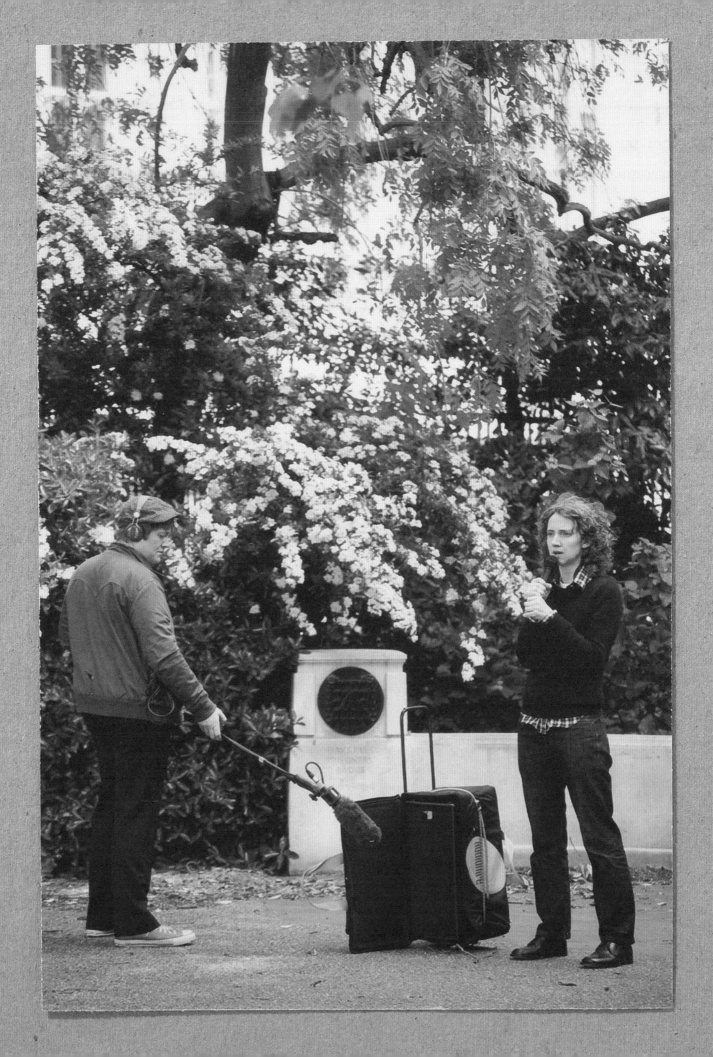

← Sharon Hayes, *Love Address*, Institute of Contemporary Arts, at the statue of Emmeline Pankhurst, Victoria Tower Gardens, London, Becca Blackwell (other performer), performance still, 2009.

← Sharon Hayes, research still, Harpswell, Maine, 2010.

In the early nineties we called him *Jessehelms*. The two names blurred into one, a curse. A curse is a repository for what is feared or hated—each time it's uttered, it buries its target ever deeper. This curse began deep in our throat with a name that sounded like a sigh, shimmered with ungendered promise, and finally hardened into *helms*. We were culture warriors, also cursed and familiar with the power of curses. If you heard us spit his name out, you knew we weren't thinking of the helms of ships, we were thinking of helmets. We felt the need for protection. Each time we said the name we were reminded of how easy it is to be broken.

In the world of this sign, he's just Jesse. In a family-friendly, lower-case font. All the rough edges are rounded off, there's nothing to catch your clothes on, it is a sturdy couch of a name. The sign invites you to climb on top of this name, bring the whole family with you, it encourages you to fall asleep and let *jesse* do what he has to. The designer of the sign wanted to stop with this one word. But the state GOP made him put in "HELMS," so the designer stuck it in, and then they said you have to say what he's running for. Ridiculous. Okay, here's a place to stick "for senate" that doesn't get in the way of "jesse." At least the GOP didn't force them to come up with a slogan. All you need is the name. Say the name, look at it—it's a promise writ in blue and white, with the *J* swooping down in a lovely curve. This name is a summer day by a lake, it's as deep as yes, and you can look into it and see all the way to Jesus.

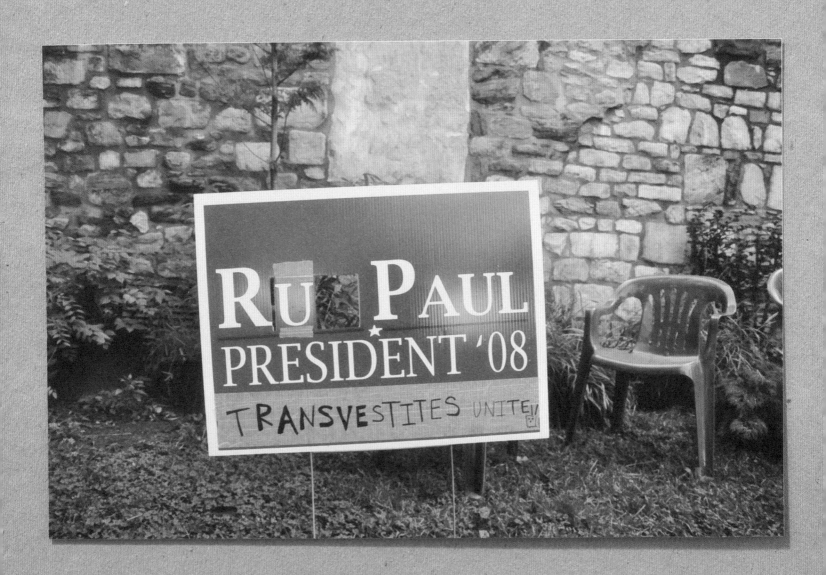

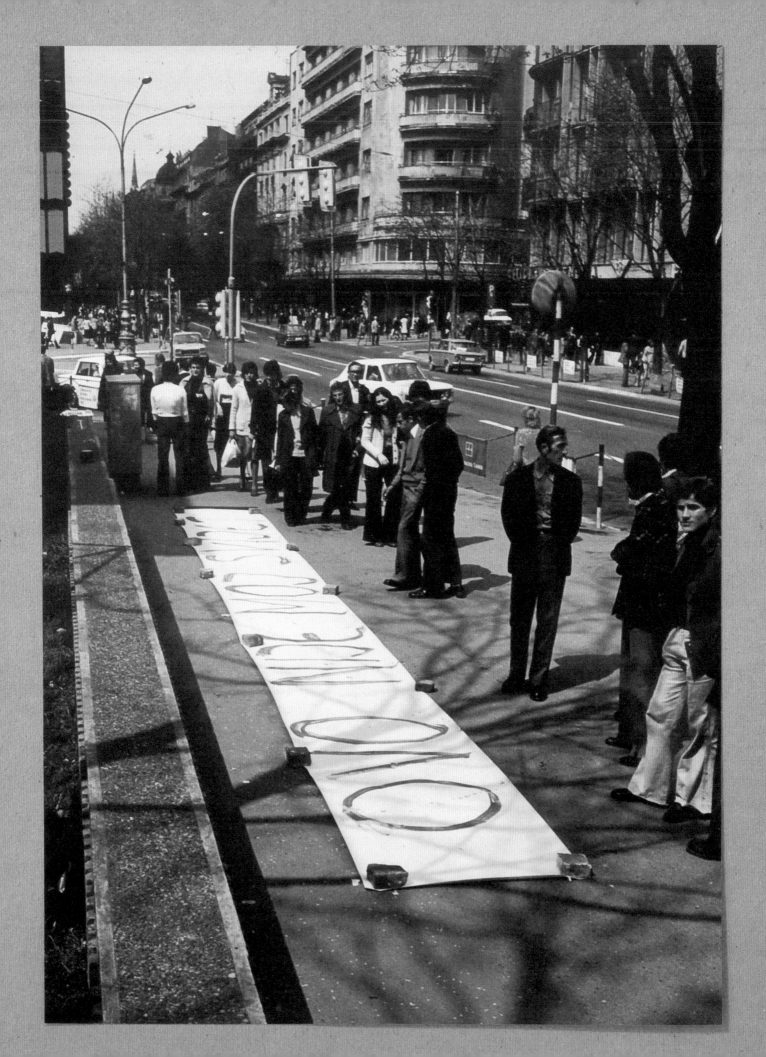

Željko Jerman, *OVO NIJE MOJ SVIJET (This is Not My World)*, ink on photographic paper, first exhibited on street in Belgrade, 1976. Text by What, How & For Whom/WHW.

When looking at Željko Jerman's 1976 action, "This is not my world," it is hard to extract this scene from its original context. It is by all means rooted within the Yugoslav cultural and political context, but also the context of the Group of Six Artists, active in Zagreb from 1975 to 1978. Jerman was one of the members. All the members were concerned with the interventionist possibilities of conceptual art, "non-expensive" means of artistic production and, especially, immediate and direct action in public space.

"This is not my world" is one of a series of intimate statements that intervened in public spaces during the group's "exhibition-actions" melding private and public. Although clandestine exhibiting of this proclamation at the Republic Square in Zagreb, the city's main square and important symbolically, is a clear act of social criticism, it seems simplistic to impose an exclusively "dissident" reading on it. Similarly this photograph of Jerman's work on the street in Belgrade, should not be viewed exclusively as an example of institutional critique. The two actions did not represent a direct confrontation, but rather a political desire to directly communicate with the surroundings, and demonstrated a clear need to voice a protest in the specific timeframe and social context. Through changing art, its modes of production and presentation, and whom it speaks to, Jerman's actions simultaneously demanded and provided a foundation for a radical alteration of the world they were created in. For Jerman this involved the idea of "elementary photography": photography without the camera, created through direct contact of the artist with the chemical developing agent, and the photo-paper.

Today, when physical and mental space is regulated first and foremost by capital and legislation is more authoritative than in the previous socialist system, often called totalitarian from the revisionist perspective, we realize that the space of execution of Jerman's action was not only public space, but also the space of public-ness. Contemplating this simple, innocent, and direct message today we see it as more than a romantic artistic gesture within this space of public-ness, now long lost. Although determined by singularity (via the "my"), "This is not my world" is a clear invitation to regain the public sphere again, and a plea to reconsider whether another world is possible.

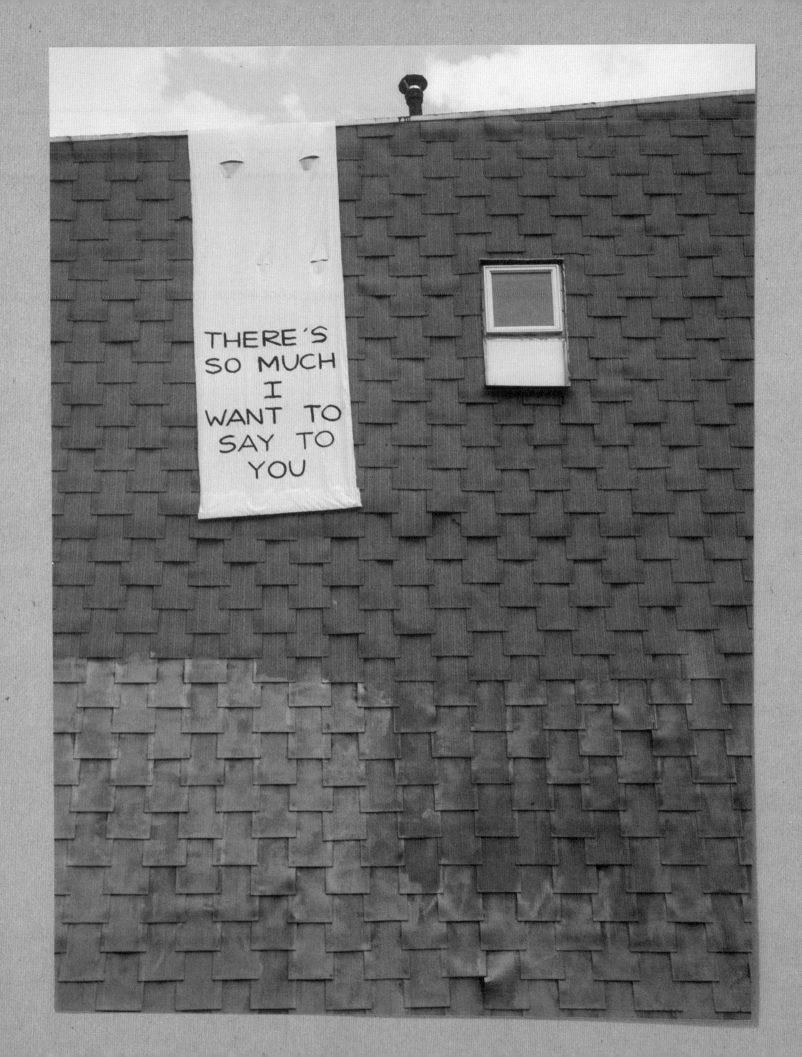

← Sharon Hayes, *There is so much I want to say to you*,
research still, New York, 2012.

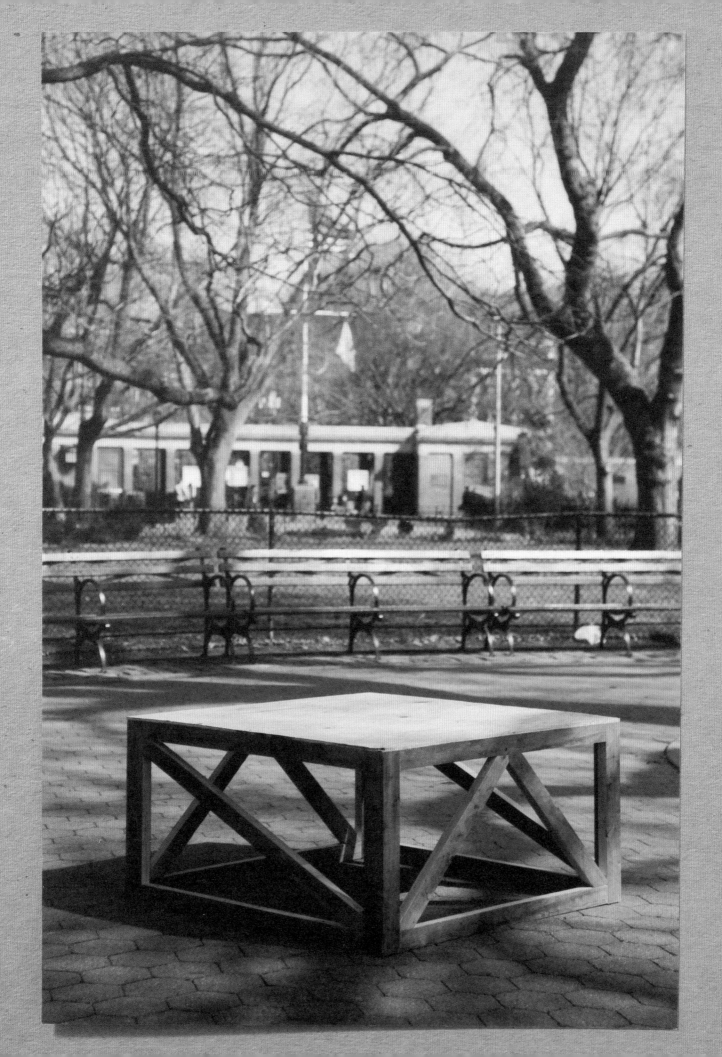

When he first heard about it, he thought it was an accident, a simple mistake, an unfortunate turn of events. He kept thinking that there is no single culprit, but that we must nonetheless rectify the situation, spread the word, reveal the injustice. This is where our responsibility lies. Meanwhile, others kept pointing out benefits that surely had been gained, opportunities seized, actions too seamless to be interpreted as mere clumsiness, actors who were clearly responsible. He listened quietly, feeling sorry for them, thinking to himself that they were paranoid, victims of their own culture, servants to their language. He wanted to tell them that the events were indeed tragic, yet one has to stay on moral high ground, one has to make logical arguments, keep to precise terminology. How can they fail to see the irresponsibility of their approach? Don't they understand they are merely repeating what has been said before? Don't they know that their words are discarded before they are even uttered? Deep down, however, he knew they were probably right, but he also knew that there was nothing to be gained, and much to be lost. Doubt crept in. He thought about it more before it became clear what he must do. Yes, he will stand there in support, but that is all he will do. He will tilt his head, roll his eyes, curl his lips and appear deep in thought, but he will not make any sound. No matter what anyone asks or says, he will not be made to speak. He will merely listen and perhaps recite to himself that statement he knew to be true, that there is an intolerable violence to interpretation—one that, no matter how hard he tried, he was certain he could not bear.

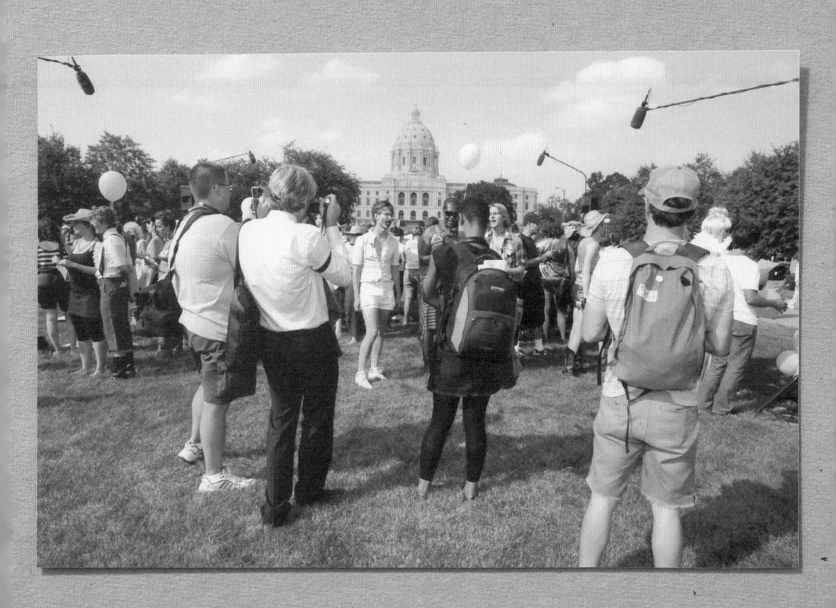

Sharon Hayes, *Revolutionary Love: I am Your Worst Fear, I am Your Best Fantasy*, production still, St. Paul, Minnesota, 2008. Text by Saeed Taji Farouky.

Abominable things these machines—you can't reason with them.

(Sorry it took me so long to write back . . .)
(Sorry, I didn't mean to sound so glib. Writing isn't the best way to express this . . .)
(Sorry for the delay)
(I'm sorry to be a little slow picking up the thread on this, but you know how it goes.)
(Sorry I've taken so long to reply)
(We are sorry to inform you)
(Sorry to disappoint but good luck in placing it elsewhere)
(Sorry it took longer than expected)
(Sorry to give you the same answer)
(Sorry I forgot to thank you again)
(I'm sorry I can't make it)
(Sorry not to be more positive)
(Sorry for having kept silent for so long)
(Ok, ok, I am sorry)
(Oh, I see. Sorry, I misunderstood)
(Sorry for the confusion)
(Tell Ghalia I'm sorry I didn't call her when we left Dhahiya)

The machine is a participant. The machine is a character. The machine is memory distorted by proximity and desire.

"The funny thing is, I only remember the bad times. I can't remember any good times."

The machine is behind an empty cafeteria table. To its right is a half-open window, through which white sunlight blinds us.

Due to copyright reasons the original text has been removed.

The machine is a weapon. The machine is subversion and provocation, "an insurrectional act." The machine is a tool of violence.

(Sorry I have made a mistake as well)

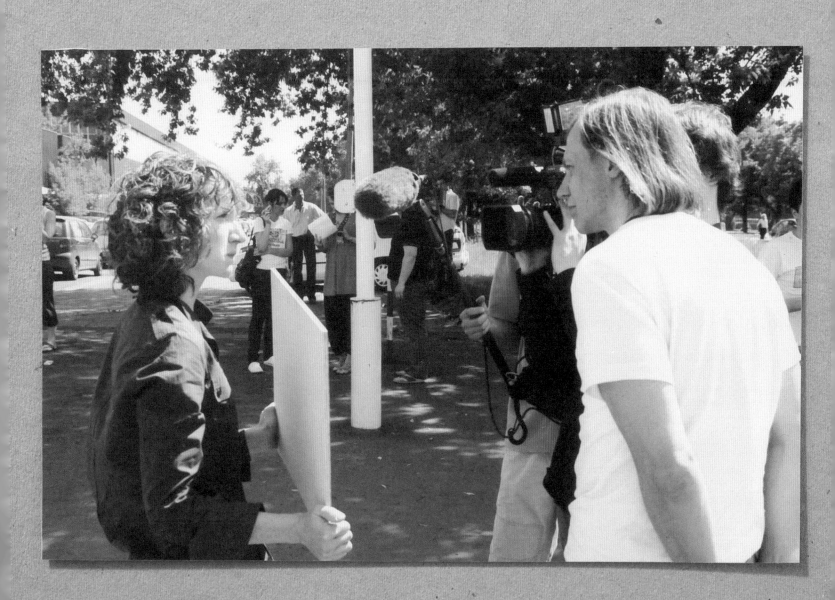

Sharon Hayes, *In the Near Future: Warsaw*, performance still, 2008. Text by Claire Bishop.

The image shows the artist holding a placard. We can't see what is written on it, but curator Tomek Fudala tells me it reads "Była, jest, będzie," the Polish words for "It was, it is, it will be." The work is one of a series of pieces that Hayes undertook in different cities during the mid- to late-2000s. The artist stood alone in the street holding a placard that bore a hand-painted slogan, usually a text taken from (or evoking) the concerns of a previous era. The message is abstract, but in Polish it is grammatically feminine, possibly cueing viewers to a slogan used by the communist government in the 1940s, but also by Solidarity in the 1980s: "Poland was, is and will be here."

This work by Hayes is typical of the 2000s in its invocation of a previous era of direct protest. During this decade, many artists made videos of demonstrations, re-enacted gestures of protest, or emulated the visual imagery and signifiers of dissent. This type of work arose because the public sphere was perceived to be under threat from an all-encroaching privatization, whereby expressions of opposition were minimized and discouraged.

The presence of three journalists who face the artist, holding a video camera and a microphone, also date this work to the 2000s. In previous decades, Hayes's intervention would not have been so readily registered by museums or the media. Today, the museum not only commissions this work, but facilitates its circulation in the media—although arguably this is done primarily to give visibility to the institution, rather than because the artist desires such publicity. In this instance, the effect is particularly poignant: the press are confronted with an evacuated form of protest, since the artist is not presenting an identifiable cause that needs to be reported, but rather a reflection upon the visual language of protest, melancholically embodied in a single individual.

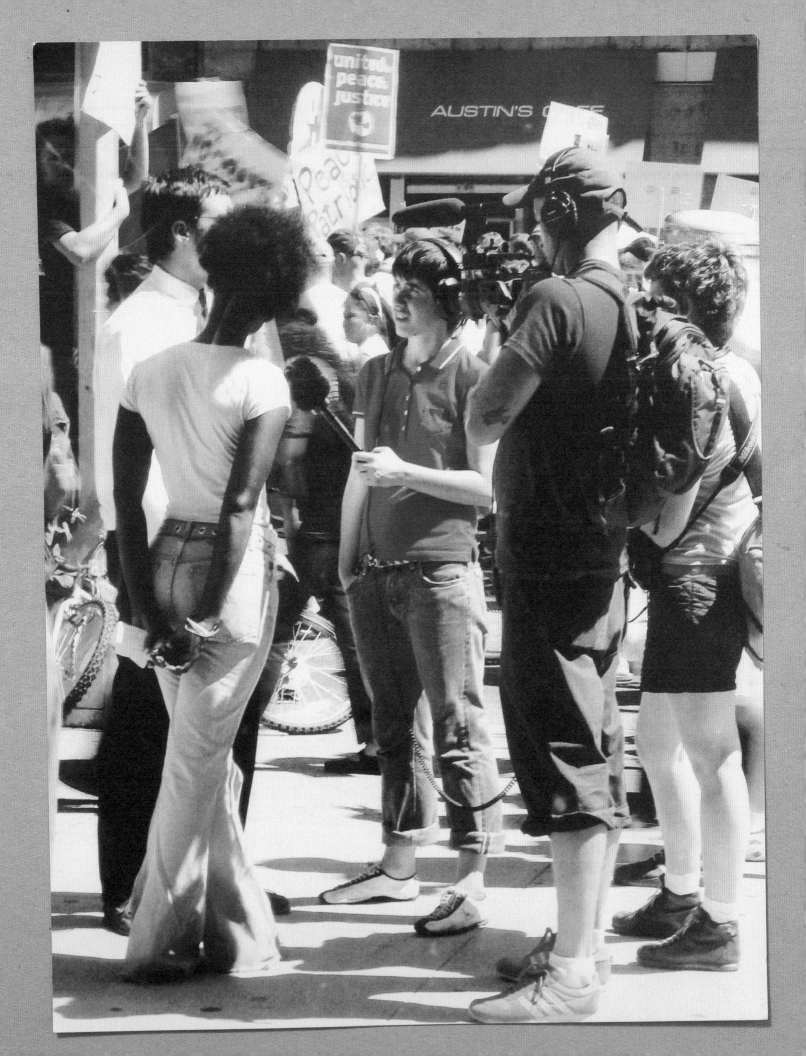

← Sharon Hayes, *After Before*, Kemba Bloodworth and
Ewa Einhorn (interviewers), Ashley Hunt (camera),
production still, 2004.

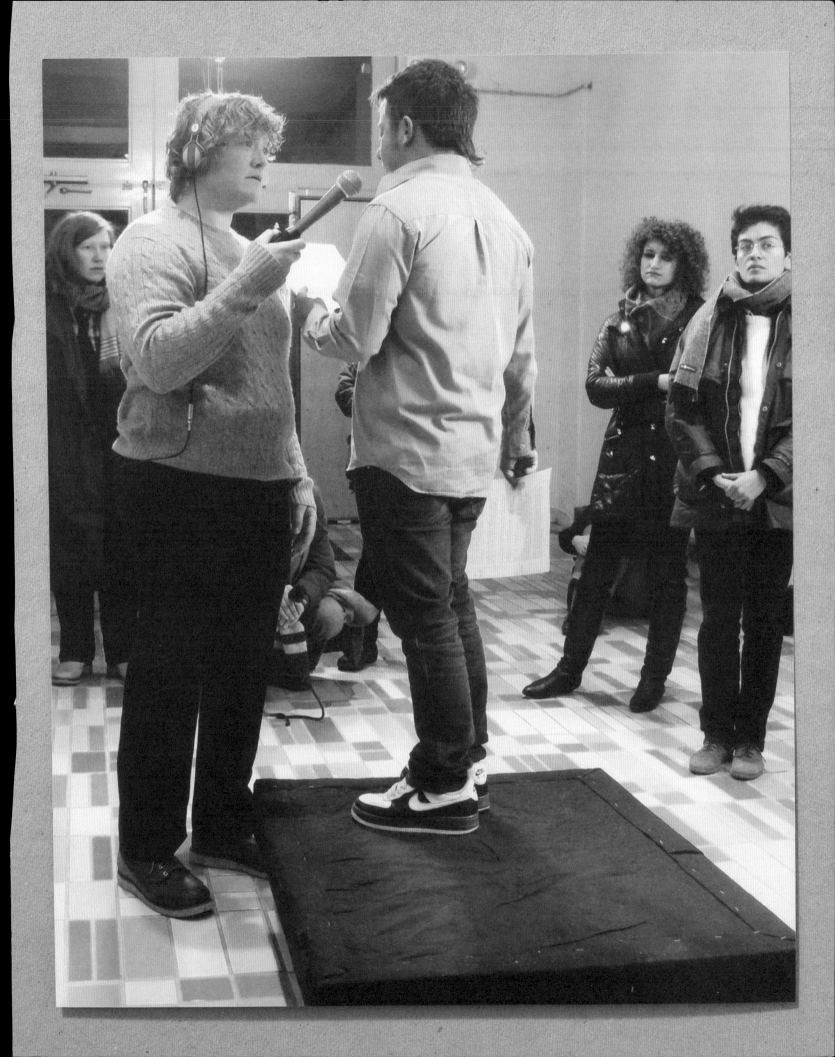

← Sharon Hayes, *Parole*, Becca Blackwell and Oliviero
Rodriguez (performers), production still, 2010.

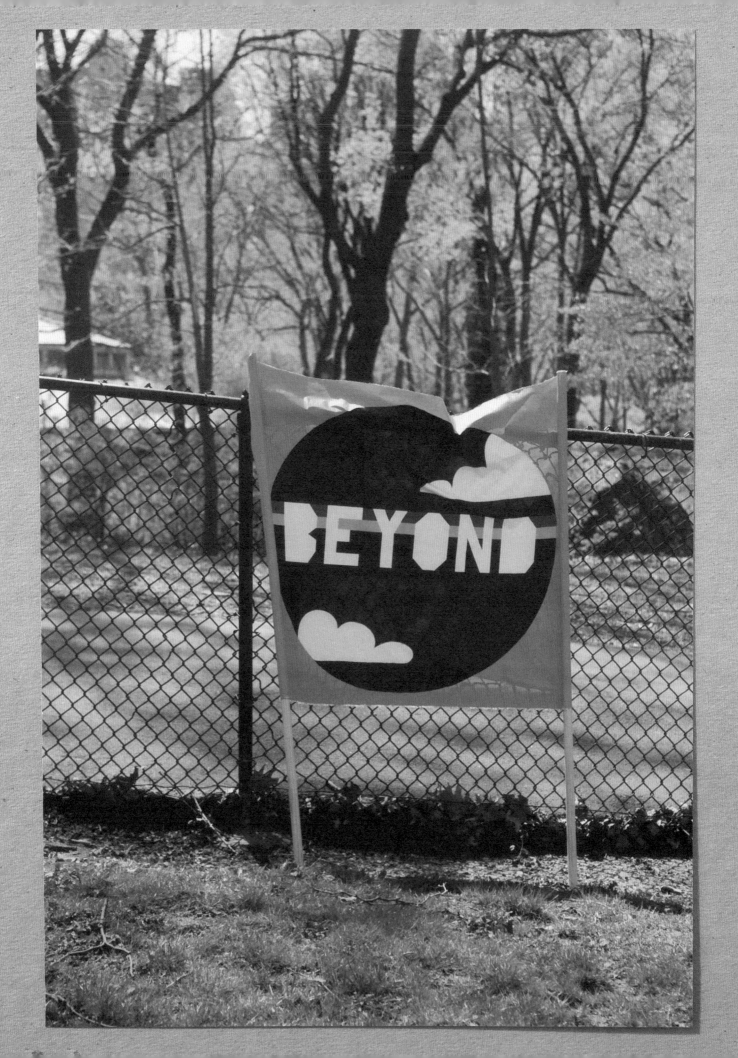

Of course, I understand your decision to "not waste words" on Reagan. What a compelling idea, not wasting words but actively deploying them in affinity and affiliation. If you don't mind me continuing the conversation, your response itself was helpful for me.

To answer your question, I don't know what I'm doing in the book. I suppose in imaging speech or bodies, scenes, demonstrations related to speech, I am somehow trying to write a text, a visual text in a sense, about things that speak, or are spoken and then heard.

I want to get further in understanding the ways in which speech is deployed. By whom and to what end? The transit and travel of a given speech act. The conditions of intelligibility. What are the precise ways in which a so-called conversation unfolds publicly, and in doing so, exponentially speaks?

I've been thinking a lot about rage in relation to speech. I've been mulling over the still of Anita Bryant being pied in the face. Thom Higgins's action to halt speech.

And here, I spent a long time considering the question you posed: when do we get to hear the world to which we want to listen?

I'm not sure why I got so suspended on that.
There is such a cacophony of sound in the world, even before I recognized myself as a political person, I felt overrun by things to listen to, things I couldn't help but hear. And yes, perhaps now I have a much better chance at making choices, at standing with cocked ear, moving with a microphone toward specific voices or bodies but it's hard to excise the experience, or what becomes (perhaps) an inevitability, of listening to things you don't really want to hear. It's oddly difficult to direct one's listening . . . desire is not always a good leader.

Listening is social, political, ideological, public, private, singular, habitual, revelatory, predictable, ephemeral, material, learned, and able to be relearned.

It is hard work to listen, though we probably spend more time doing it than almost anything else we do. But it is even harder work to be attentive to how we listen and this, I suppose, is what I've been doing for the past 15 years.

I am stopping mid-many thoughts . . . I clearly haven't resolved anything.

This volume was published on the occasion of the exhibition *Sharon Hayes: There's so much I want to say to you*, curated by Chrissie Iles, Anne and Joel Ehrenkranz Curator, with the assistance of Nicole Cosgrove, curatorial assistant.

Whitney Museum of American Art, New York
June 21–September 9, 2012

WHITNEY

Whitney Museum of American Art
945 Madison Avenue
New York, NY 10021
whitney.org

Yale

Yale University Press
302 Temple Street
P.O. Box 209040
New Haven, CT 06520
yalebooks.com

This publication was produced by the publications department at the Whitney Museum of American Art, New York: Beth Huseman, interim head of publications; Beth Turk, associate editor; Anita Duquette, manager, rights and reproductions; Kiowa Hammons, rights and reproductions assistant; Brian Reese, publications assistant

Project manager: Beth Huseman
Editor: Claire Barliant

Designed by Garrick Gott
Set in Akkurat
Printed on 60lb Natural Book and 16pt Indacote C1S cover
Printed and bound in United States by Shapco Printing

Library of Congress Cataloging-in-Publication Data

Sharon Hayes : There's so much I want to say to you.
 pages cm
 This catalogue was published on the occasion of the exhibition Sharon Hayes: There's so much I want to say to you, curated by Chrissie Iles, Anne and Joel Ehrenkranz Curator, with the assistance of Nicole Cosgrove, curatorial assistant.
 ISBN 978-0-300-18037-4 (pbk.)
1. Hayes, Sharon, 1970—Exhibitions. 2. Art—Political aspects—United States—Exhibitions. I. Iles, Chrissie, curator. II. Hayes, Sharon, 1970–
Works. Selections. 2012.
 N6537.H379A4 2012
 709.2—dc23

10 9 8 7 6 5 4 3 2 1